My diary Mio Matsumoto

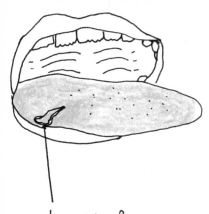

I'm dying?
I thought it's only an ulcer, but the Doctor said
it could be a cancer of the tongue....

Great! first thing I was told was "Be prepared for the worst situation...." .

from the bus window, I thought
BYE BYE London. 🖐"

01 / 07 / 02

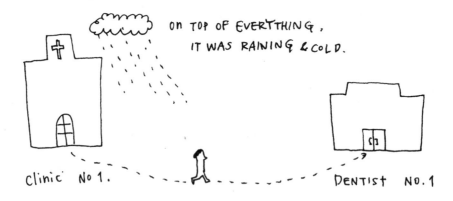

ON TOP OF EVERYTHING,
IT WAS RAINING & COLD.

Clinic No 1.

DENTIST No. 1

ALL DAY, I WASN'T DOING ANYTHING.
JUST WALKED FROM ONE DOCTOR TO ANOTHER.

Is it getting better ??? ?
my tongue hurts....
very painful indeed.

pillow

bed

duvet

my stomach hurts, too.
why ???

5th July :
2 weeks have passed since I visited a doctor & a dentist.
I'm with the dentist now but my tongue still hurts.

Hara booked an appointment for me to see a specialist.

Tick
Tick Tick Tick
 12
 9 3
 6 ⑨ — appointment time.
Tick

I wasn't calm.

Hara came with me to see the specialist.

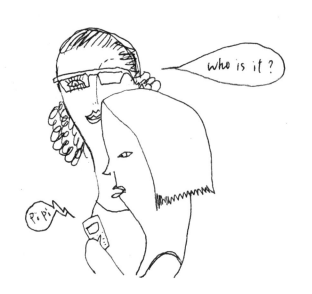

Got a message from him,
 just the right after it

The doctor told me that he thinks it's an "Ulcer"
but better to have biopsy to make sure exactly what it is

a bit better today.

17th July Wednesday

I had an appointment with my dentist.
I told her that I need her to do a biopsy ASAP!
But she said that she can't do it yet that was enough!
I decided to go back to Japan !! I couldn't wait any more.

yeah. I think
you better go home.
you already seem
far too tired.

Go Go! have a rest.

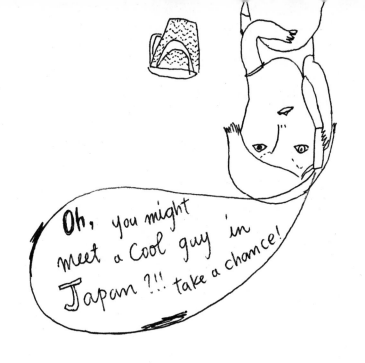

----- I think (he) this is the main reason that I'm ill.

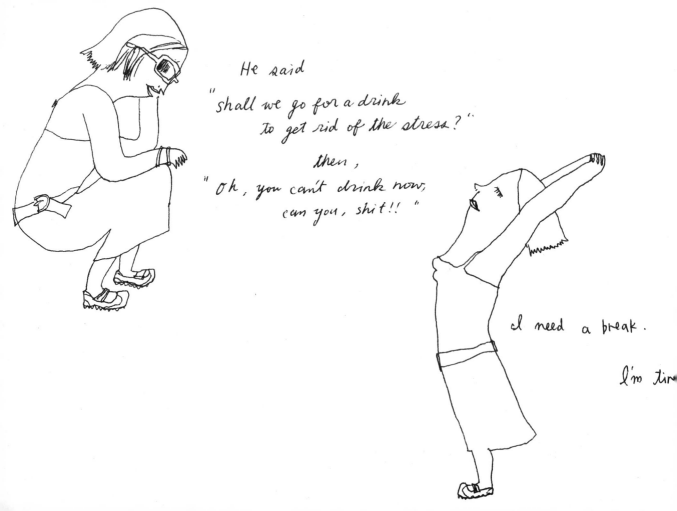

He said

"shall we go for a drink
 to get rid of the stress?"

then,

"Oh, you can't drink now,
 can you, shit!!"

I need a break.

I'm ti

Take off to Japan 19th July 2002.

when Luca was here,
the moon was ☽ .
9:47 pm I'm (was)
off.

I went to see a doctor in Japan.

couldn't sleep well... I was scared...

To be honest,
I felt so scared of what would
happen, if my situation is the worst case...

STILL IN SHOCK...

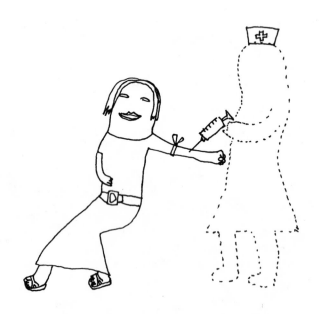

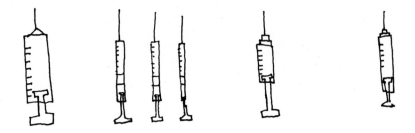

So far I have had 5 injections ...

I wanted to make myself busier cos I didn't (don't) want to think about it too much.

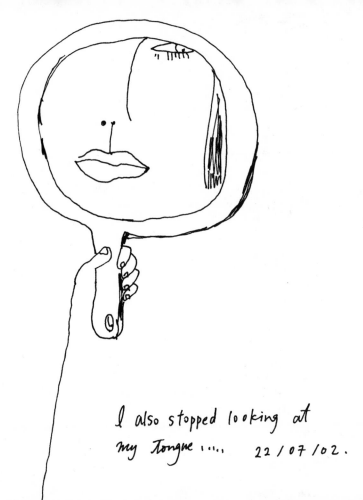

I also stopped looking at
my tongue, 22 / 07 / 02.

the worst thing is that,
mentally, I am not strong enough.
But at the same time, there is
no one who ~~can~~ I can feel secure
with either

And another friend of mine said that I am too picky which I admit but can't help.

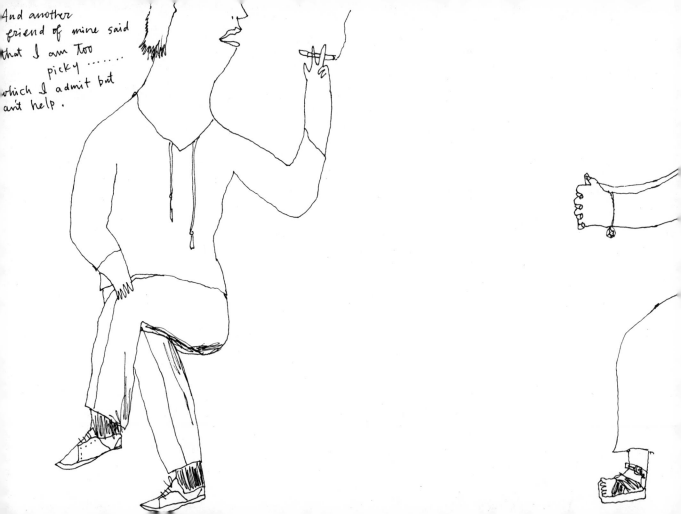

25th July 02 @ 9:00 pm
I had to drink

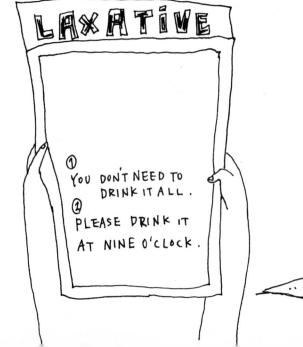

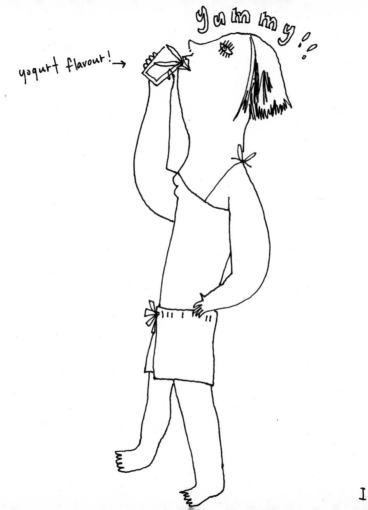

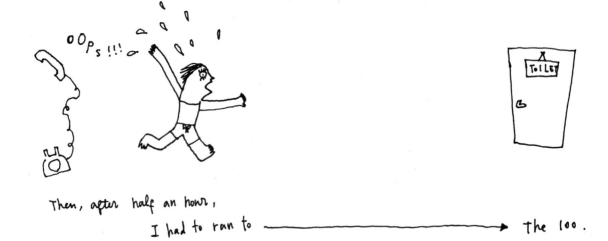

Then, after half an hour,
I had to ran to ——————————→ the loo.

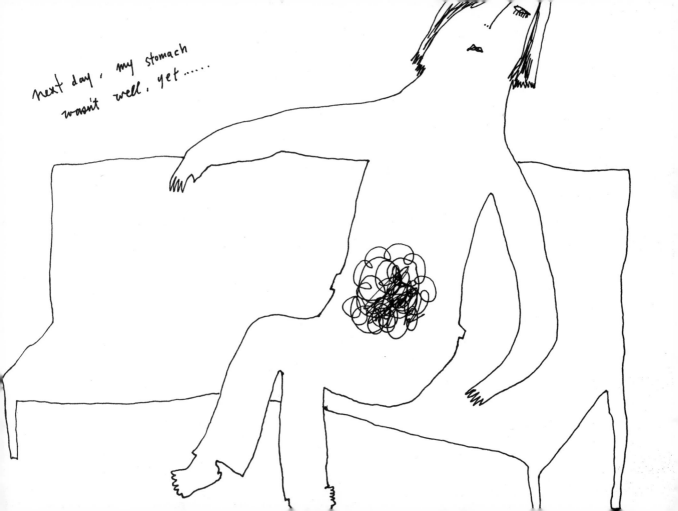

I thought " it's like <u>ER</u> (TV programme) " .

while they were scanning
my whole body,
my heart was beating
so hard and quickly which
surprised me a lot.
But I couldn't control it ...

The doctors told me
that
I've got a

CANCER
CANCER
CANCER.

and on top of that, it's malign.

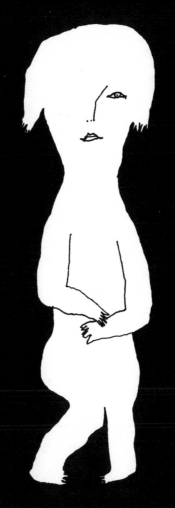

I knew it.

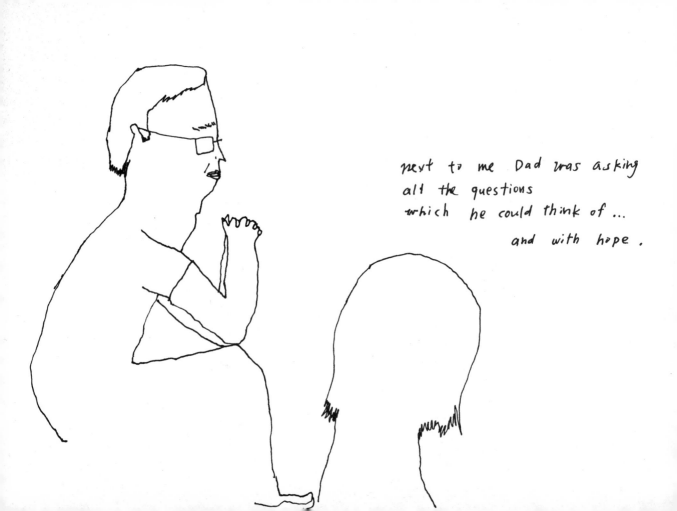

next to me Dad was asking
all the questions
which he could think of ...
 and with hope .

On the way back in the train he told me

"It should have happened to me

but not you ."

I don't think so.

I don't know, but I really
didn't think or wish
somebody else ~~with~~ would get
what I got.
It ~~was~~ actually surprising to
me that I ~~was~~ quite calm.

My mum said

It was good to talk to you
this morning.
What you said made me calm.
and helped me to understand
that you accept your
misfortune.

I was very negative which
 I didn't notice by myself. And he was so positive which
 made me realize

 how lucky I was / am .

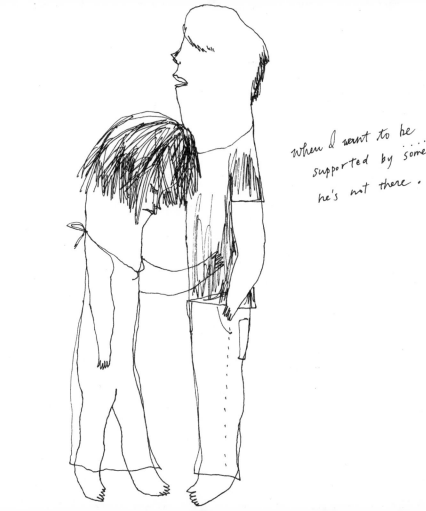

when I want to be
supported by somebody,
he's not there.

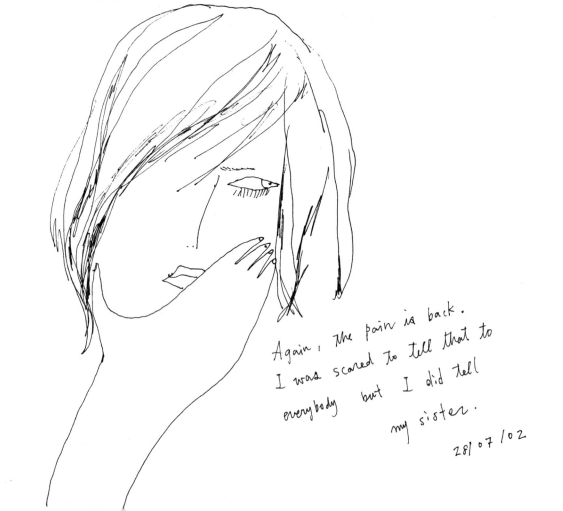

Again, the pain is back.
I was scared to tell that to
everybody but I did tell
my sister.

28/07/02

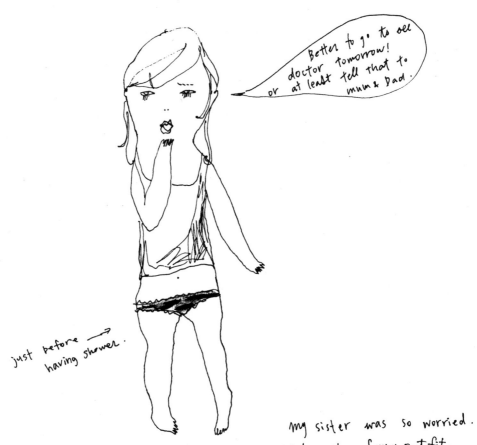

Asako was so surprised
when I told her what I've got.....

she even cried....'

The annoying thing is that
when it's painful, I feel weak.

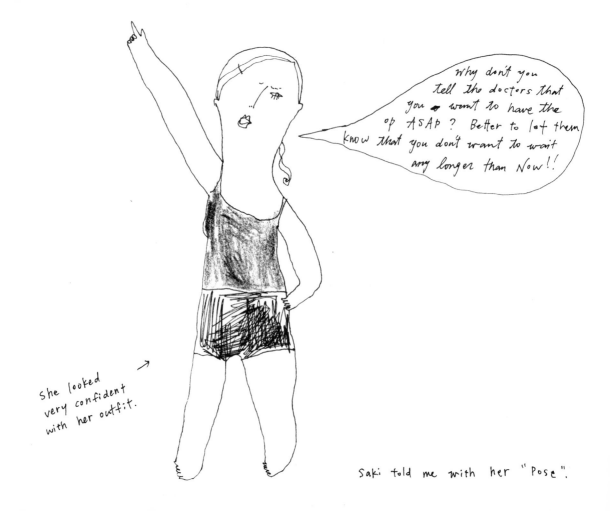

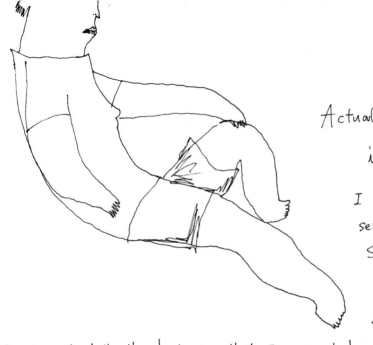

Actually , what saki said
is Right .

I regret that I wasn't
serious enough about my
situation Now.
It is happening to me
& Not to somebody else.

I had to tell the doctors that I am Not HAppy Just waiting
for another WEEK without doing Anything ······
Because I'm scared , too ······

when I looked at my mouth in the
mirror, it's just fine.

Saki told me to say in the word
everything that I feel.

if I'm scared
 "just say it".

if I'm in pain "just say it"
otherwise no one knows
exactly what I want.

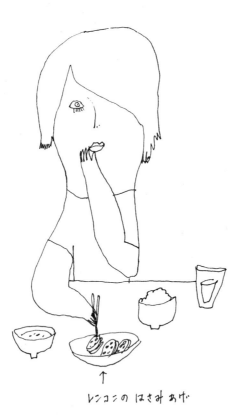

Today was my first day
that I got a problem
eating food .

29 / 07 / 02

レンコンの はさみあげ

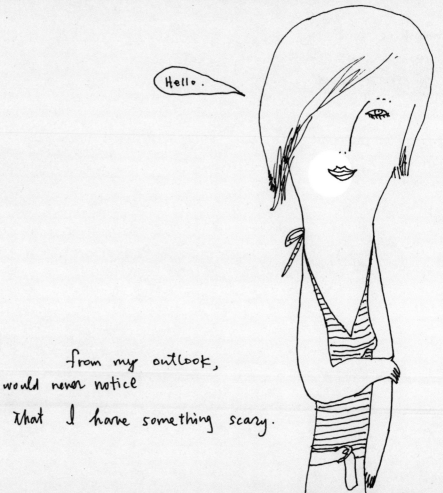

from my outlook,
People would never notice
that I have something scary.

Rang him with little excuse.
As usual he's telling me what
I HATE to hear ...

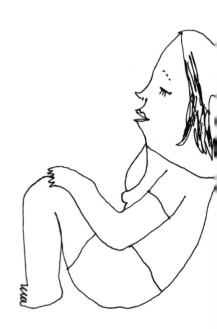

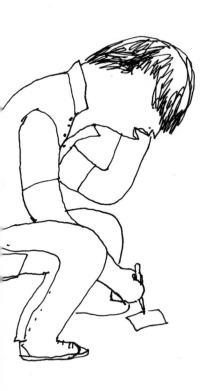

So I told him
what I hate to tell.
But, it helped me. 29/07/02

Suddenly, I cried in the night.
I just couldn't stop

 hoping this will soon be over.

I feel, this is enough to feel the sadness.

I'm scared enough so give me a hope.

GOD, Please give me a
chance.

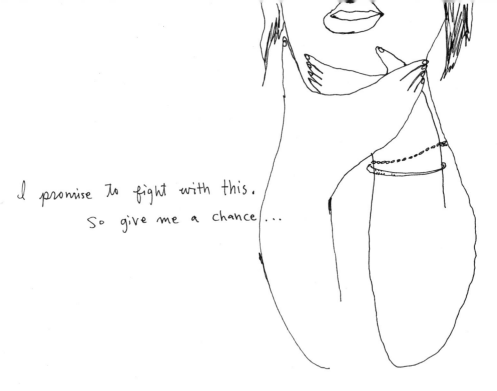

I promise to fight with this.
So give me a chance ...

What do you want from me? I have nothing, yet.

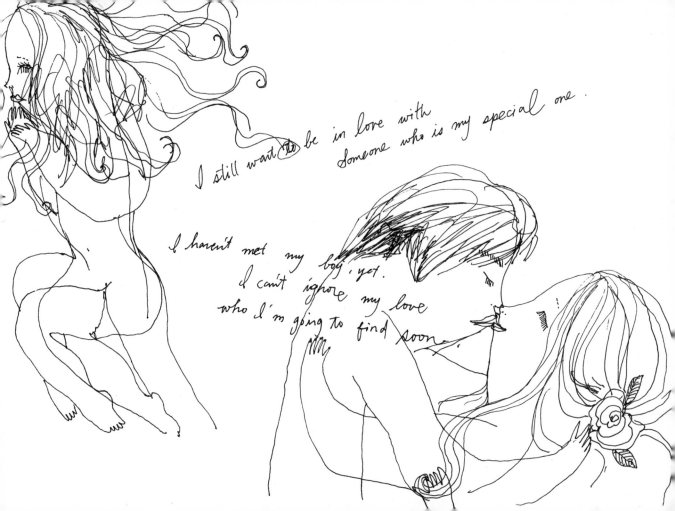

I still want to be in love with
someone who is my special one.

I haven't met my boy, yet.
I can't ignore my love
who I'm going to find soon.

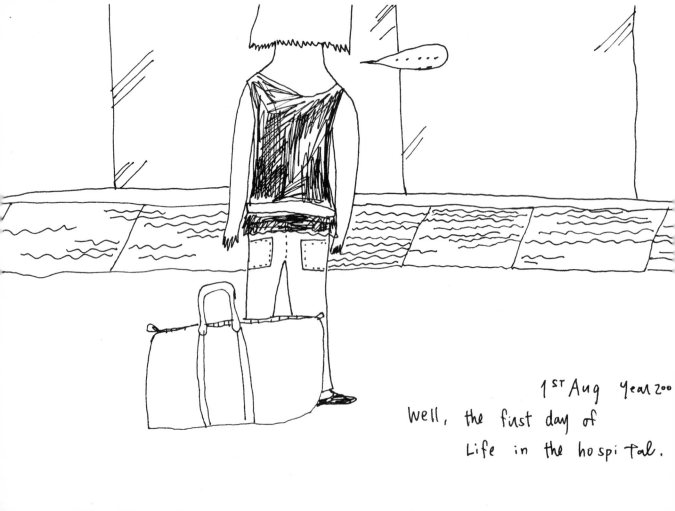

1ST Aug Year 2oo

Well, the first day of
life in the hospital.

1ST Aug 2002.

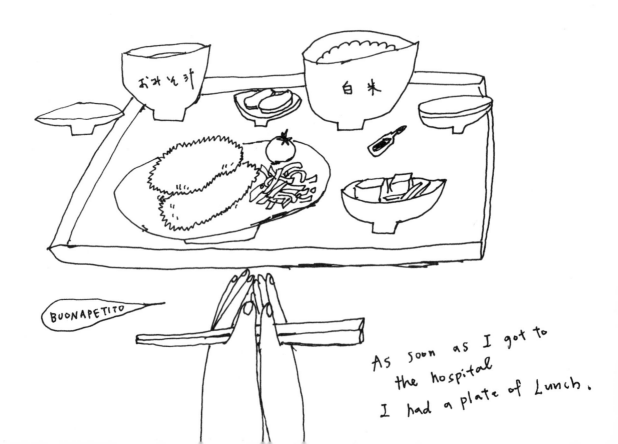

As soon as I got to
the hospital
I had a plate of Lunch.

After 6 pm, we had a meeting with the doctors.
There'll be 3 doctors on my operation, tomorrow.

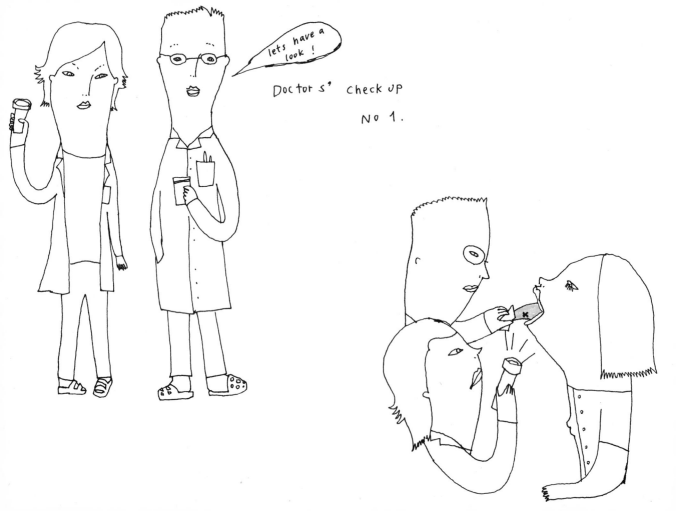

Doctor's check up

No 2.

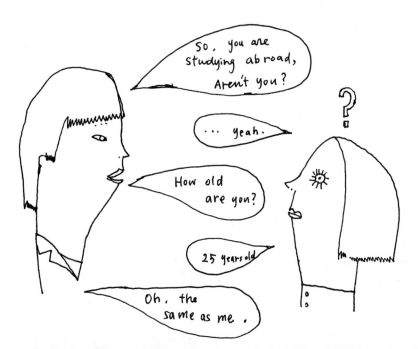

OOPS!! OOPS!!! OOPS!!!

GOD!! My Bloody ALARM started Ringing! @ 12 midnight.

great! I managed to make myself famous ~~the total~~ with the nurses on the floor.

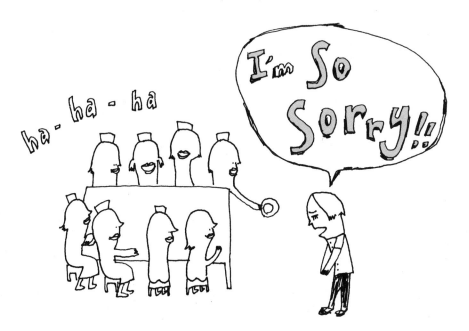

Thank you very much to the night shift nurses!!

02/08/2002

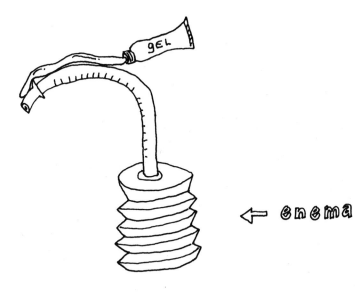

← enema

... does work so well.

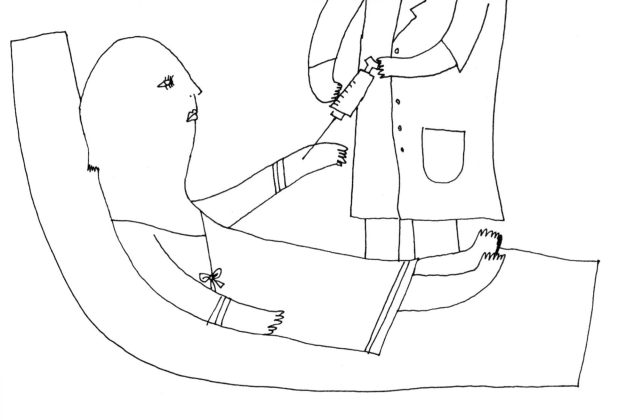

I had to change the pyjamas to a granny one.
and I had to have an ingection to connect tube. (drops)

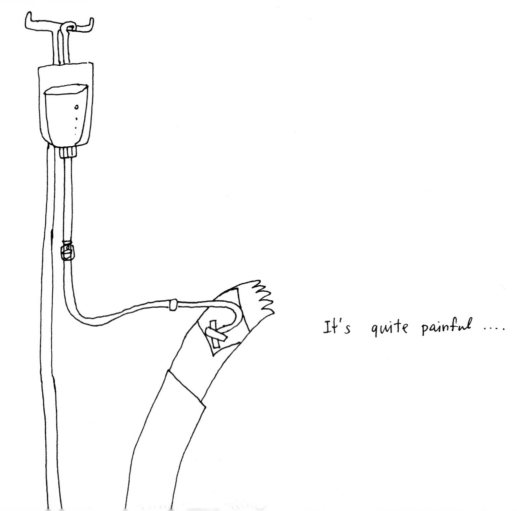

It's quite painful

Ready to go to the
 operation Room...

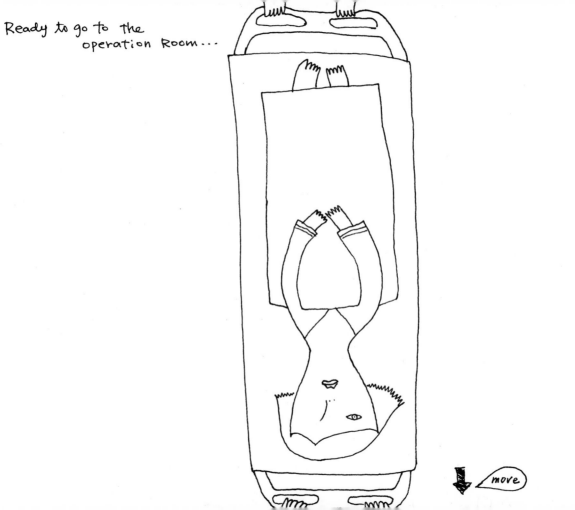

move

After I took off my pyjamas
& knickers,
I had to go on a
(like) cooking board ...

As soon as they put
a mask on me,
 I fell asleep.

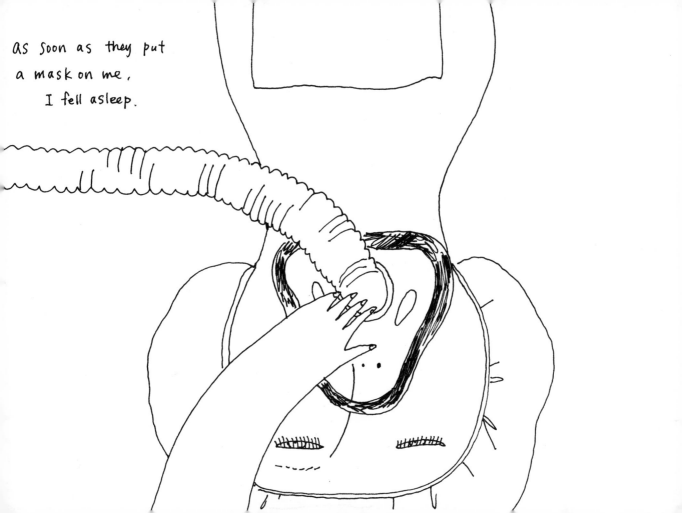

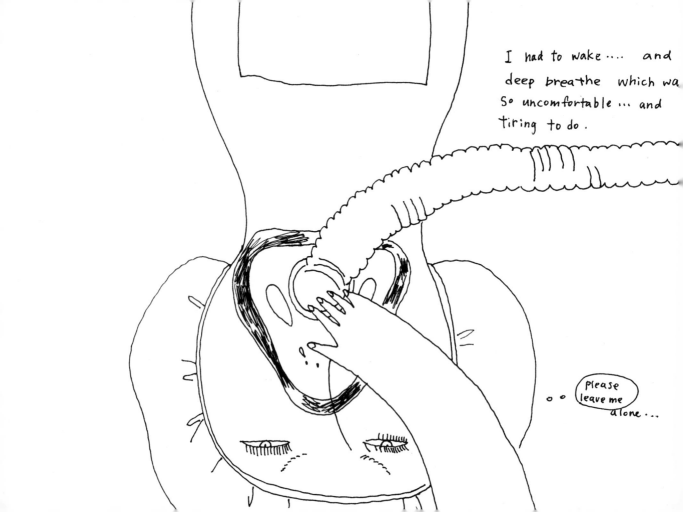

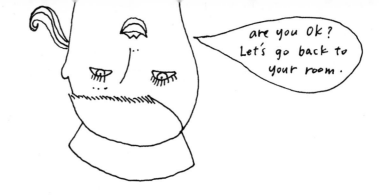

are you OK?
Let's go back to
your room.

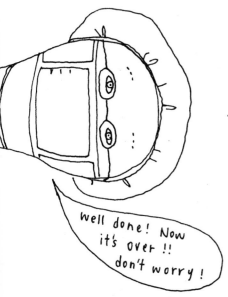

well done! Now
it's over !!
don't worry !

.... I didn't care about anything at all actually. I was very tired and couldn't be bothered to listen to anybody Just wanted to have a rest

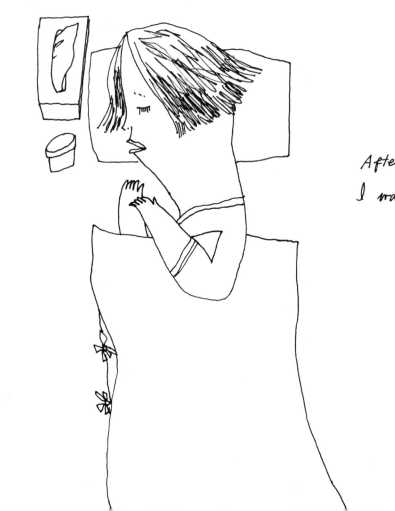

After the op.
I was feeling so weak.

this machine →
vacuums
spit & sputum.
very useful!!!

to take out the spit and
sputum, I had to use a
kind of machine.

the night of the operation, I couldn't really sleep....

the night seemed very long to me...

And probably the same for a nurse who was helping me during the nigh

... Thank you !

Recover !!!

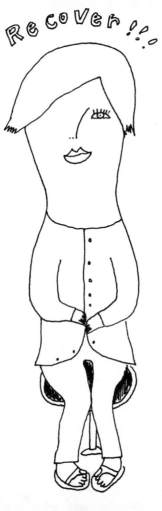

next morning (03 / 08 / 02),
I felt much better !

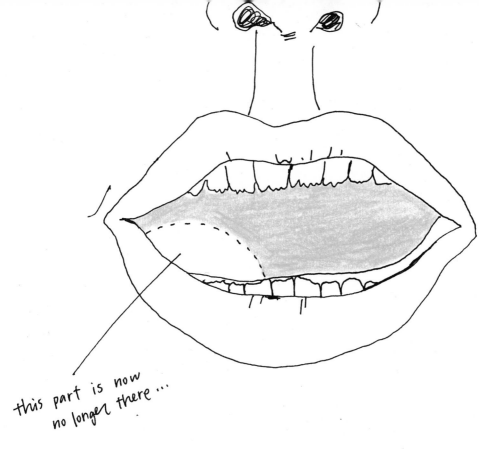

this part is now
no longer there ...

I use a straw for all of them!

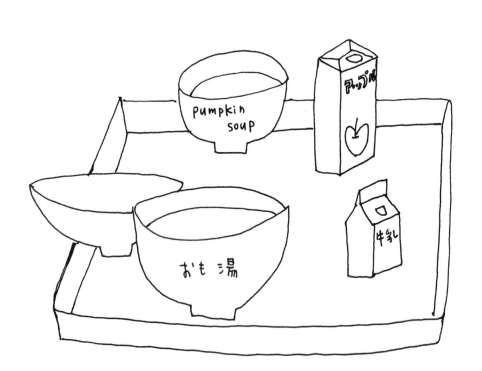

These two days, I've been only drinking, instead of eating ... because of my tongue.

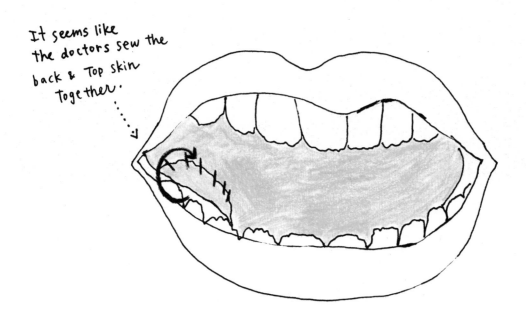

ERika chang said my tonque's colour is very good.
But I think it's very grotesque.

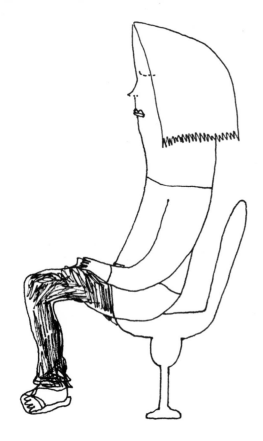

おしっこしか出なーい。
水道食っていいんだか悪いんだか．
こんなん全々 不健康 ── 。

I just waited till I felt I could go to the loo.
But this didn't work.

OOPS.....

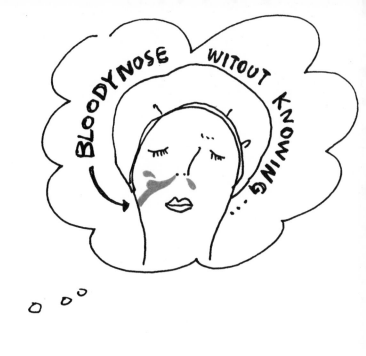

I could imagine so well that
my nose was bleeding

in the hospital Day 5

ERIKA chang

is an 18 year old
highschool girl.

She's got a problem with
her ear and is
staying with me in
my room.

her hair style was cool

very punky!
of course, it's for the operation.

"I may die ..."
I thought that at least once.
Then I found myself actually
still alive
without any worries.
Now, it's like on a cloud.

06/08/02

my medicine.
It tastes sweet
actually it's for kids.

A DOCTOR WHO I SAW
IN THE DOCTORS' ROOM
seemed my type.

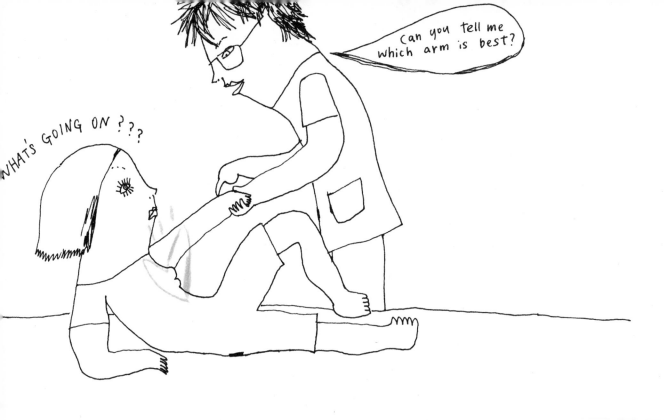

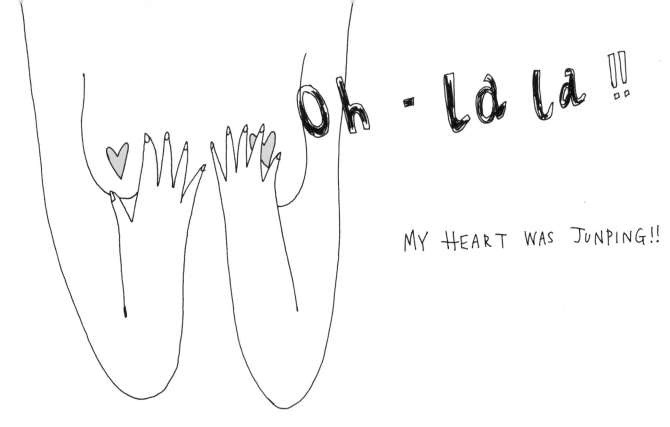

MAYBE IT'S A GOOD
CHANCE
TO FORGET ABOUT THE
HOPELESS LOVE IN LONDON?!

I know, he's my cup of tea ♡

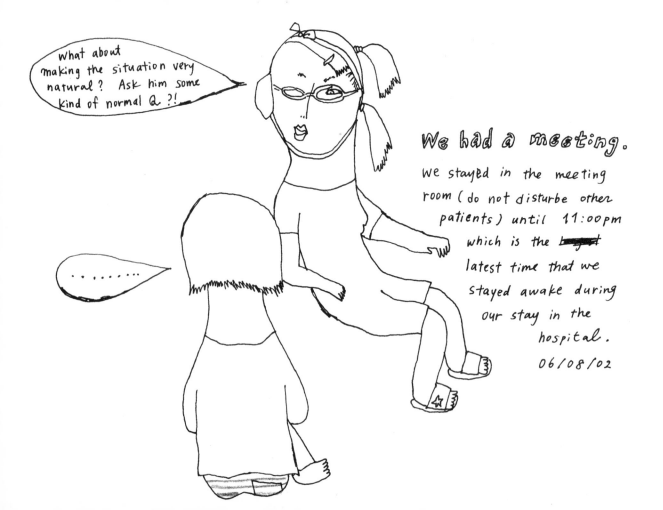

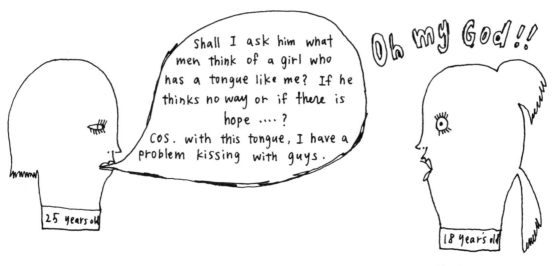

but, it's typical that I'm going t

Leave the hospital................

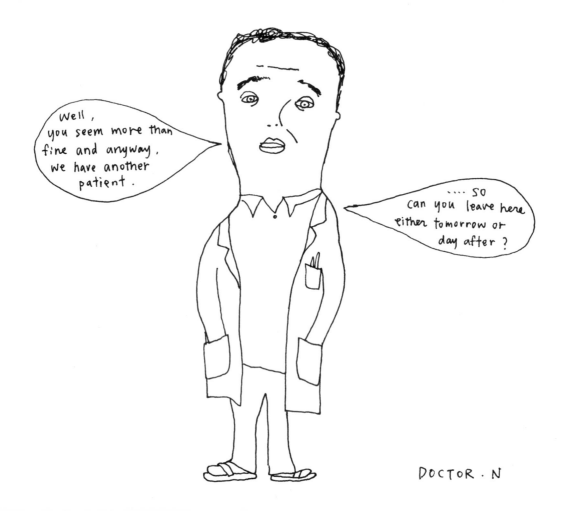

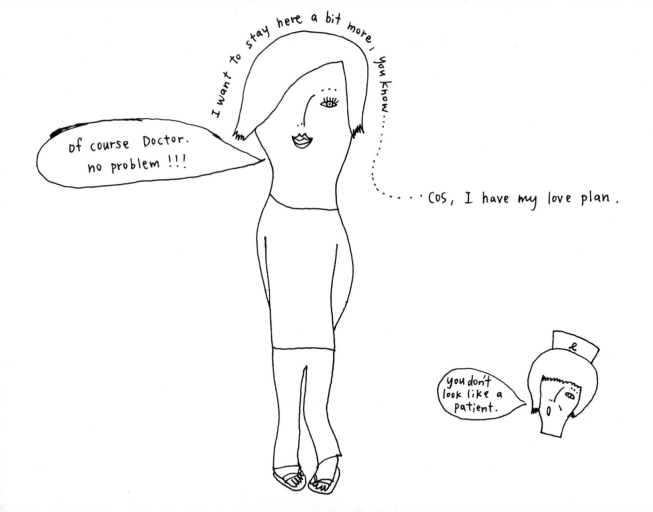

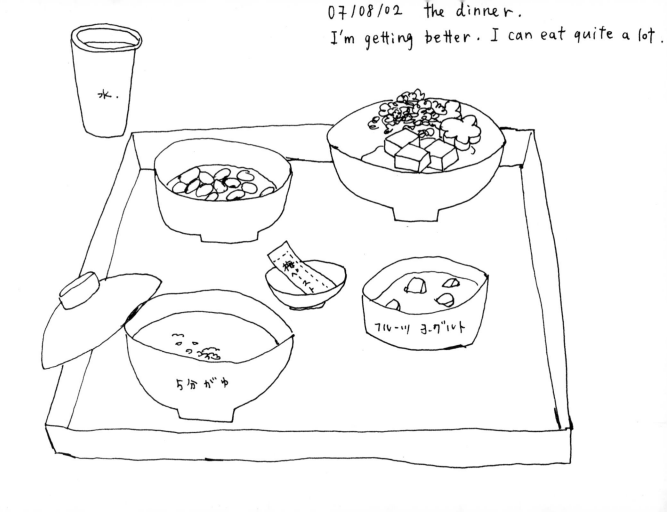

07/08/02 the dinner.
I'm getting better. I can eat quite a lot.

水.

フルーツ ヨーグルト

5分がゆ

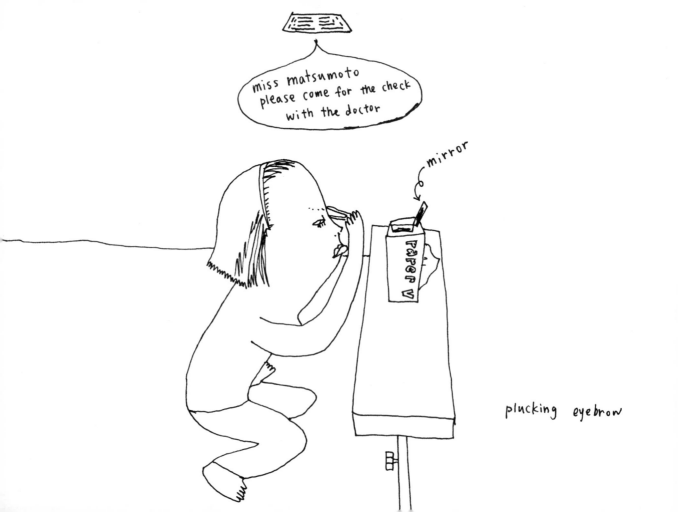

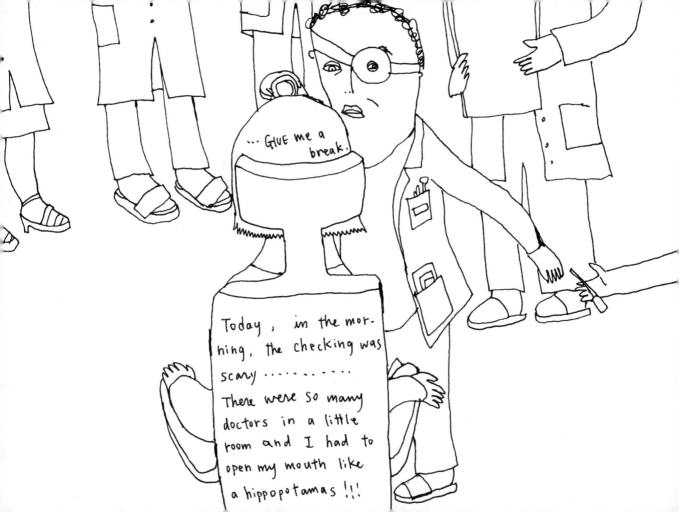

BUT, I cmouldn't find !!!!

my Doctor cup of tea

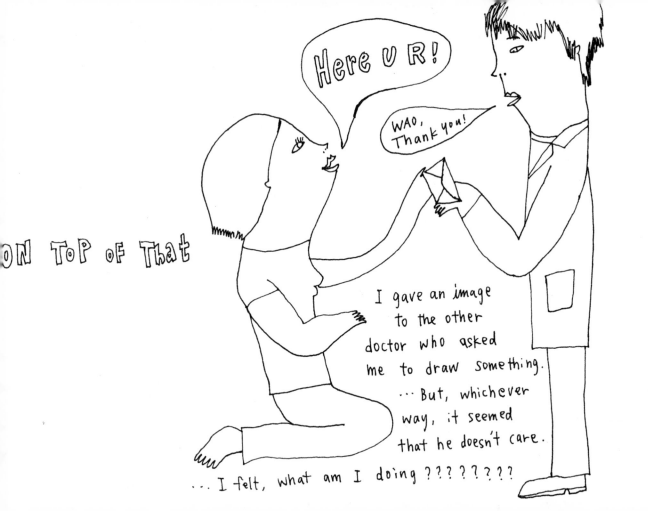

The day of leaving
the hospital.

09 / 08 / 02

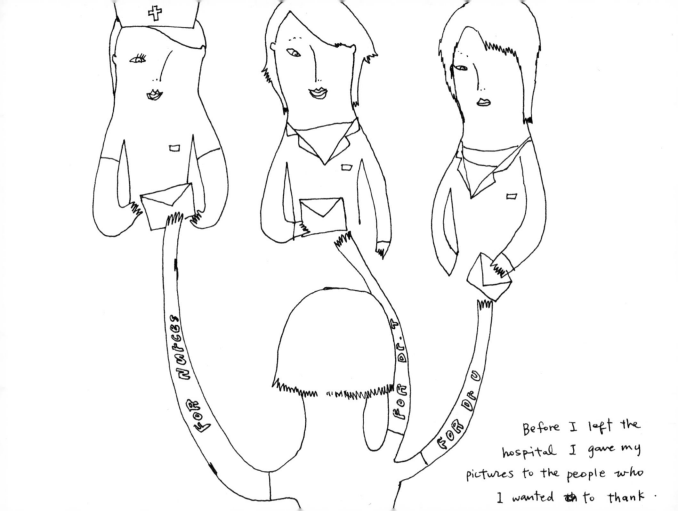

FOR NURSES

FOR Dr. T

FOR DR V

Before I left the
hospital I gave my
pictures to the people who
I wanted to to thank.

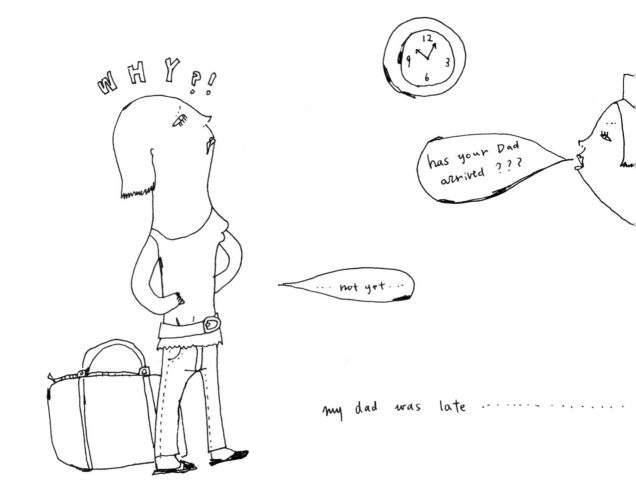

after one hour, he came.

(The excuse was a bad traffic jam).

↑
this was the
truth !!!!

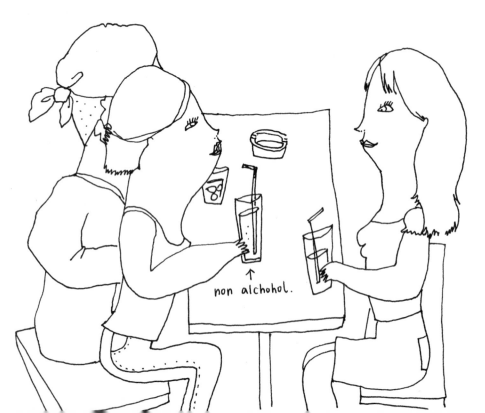

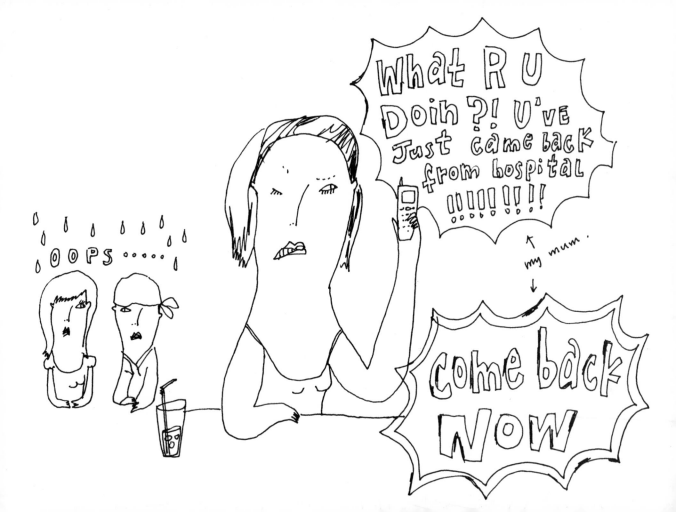

as soon as I came back home,
I had an argument with mum.

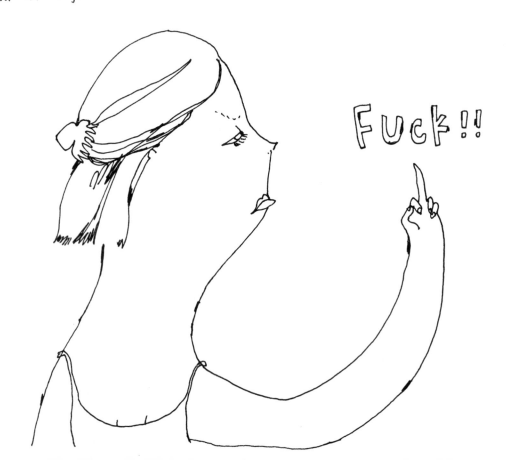

Even my sister told me off.

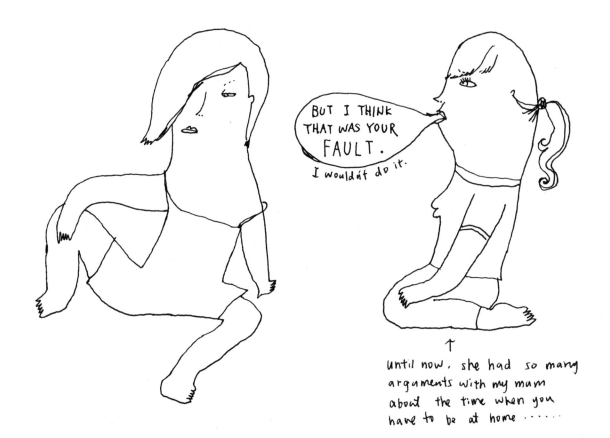

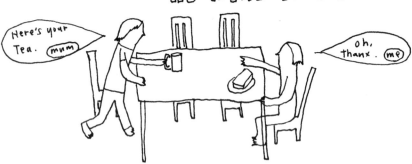

SINCE I left the hospital. I spend most of the day in front of the TV.
.... Well as you can imagine I was just being so lazy for 2 weeks by now.

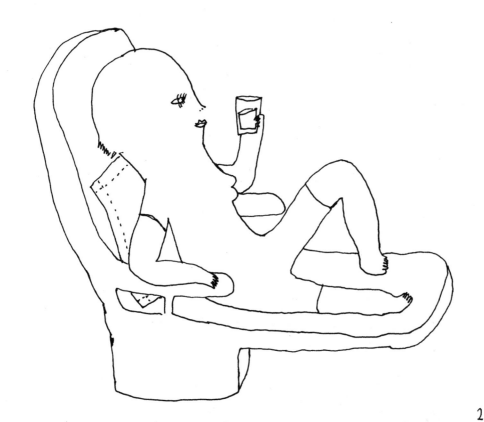

26th Aug 2002

this last 2 weeks, I had quite a lot of fun.

Come in!

on wednesday 14th Aug, I went
see the doctors
well, I wanted to see one of the

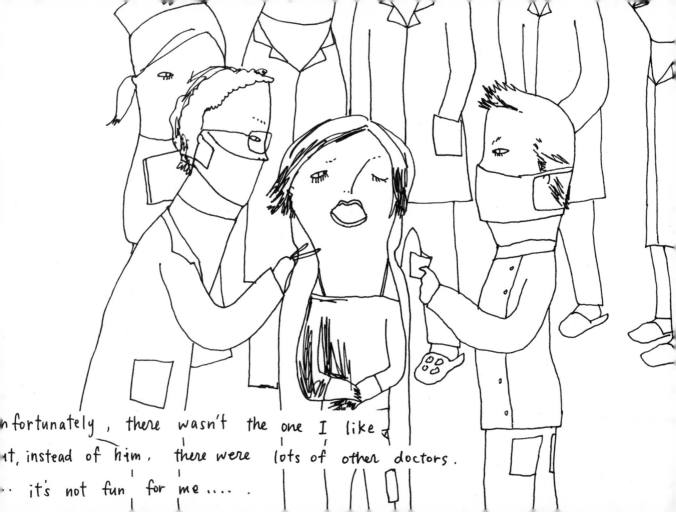

fortunately, there wasn't the one I like

t, instead of him, there were lots of other doctors.

·· it's not fun for me.....

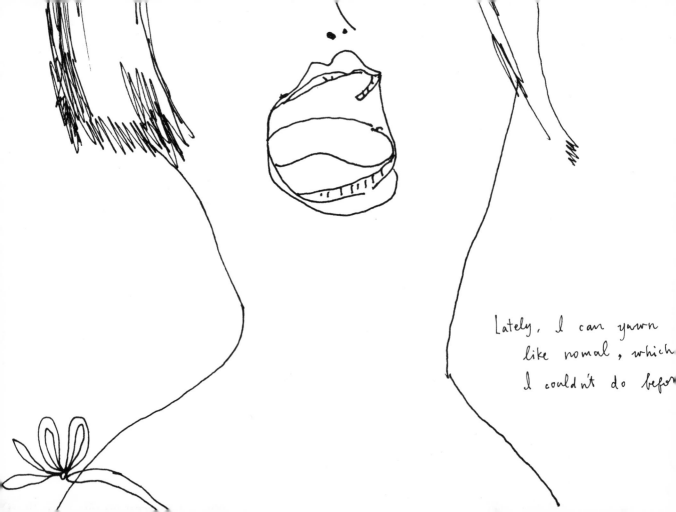

Lately, I can yawn
like normal, which
I couldn't do befo

til then I ~~was~~
~~ned~~ How to yawn
thout getting
pain in
y tongue.
emember,
you don't
open your
uth,
t's fine!

.... but,
actually
it's not that
great a feeling.

But then, sometimes
I forgot that I had to
be careful yawning.....

MUM

☆ ! ⊗ X

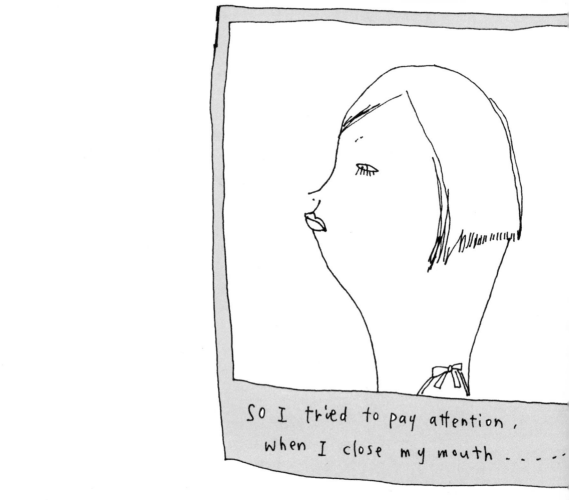

So I tried to pay attention,
when I close my mouth

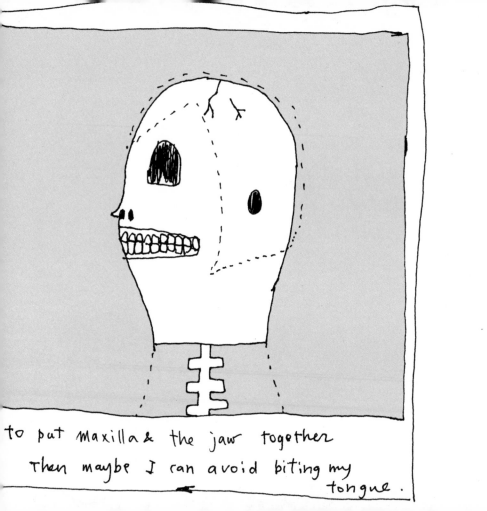

to put Maxilla & the jaw together
Then maybe I can avoid biting my
 tongue.

the day I had an apointment with my doctor,

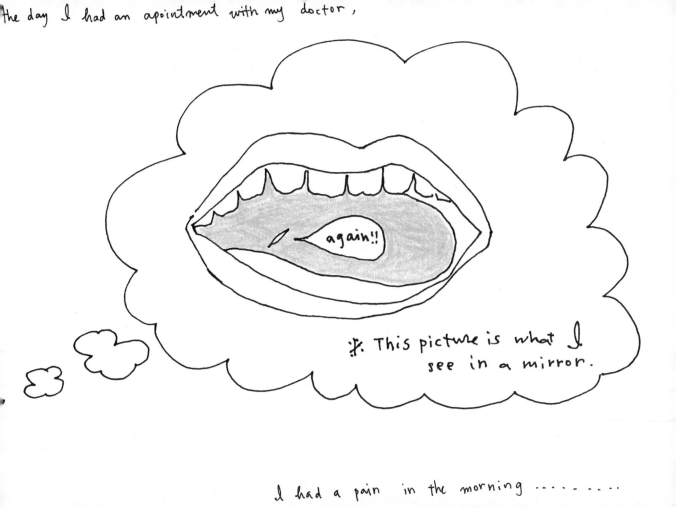

I had a pain in the morning

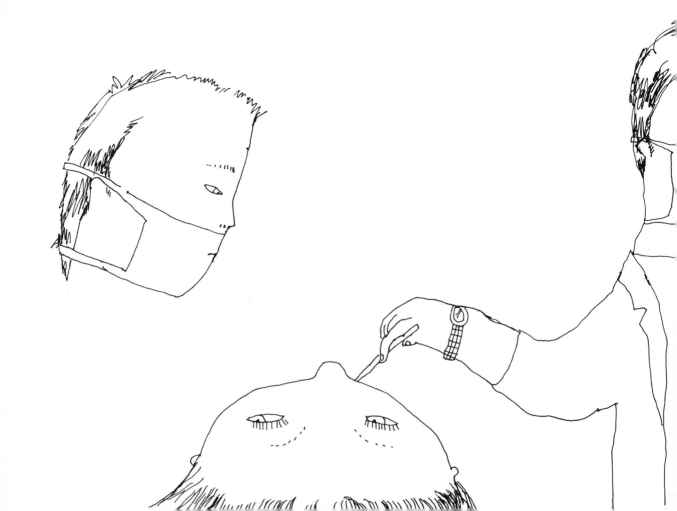

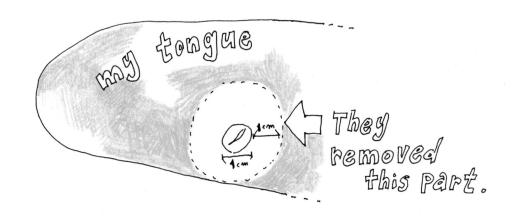

my tongue

1 cm

1 cm

They
removed
this part.

FROM
the Left side

At the beginning
I wanted to eat

curry girl!!

CURRY !!! in japanese style!!

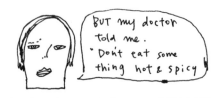

BUT my doctor told me. "Don't eat some thing hot & spicy"

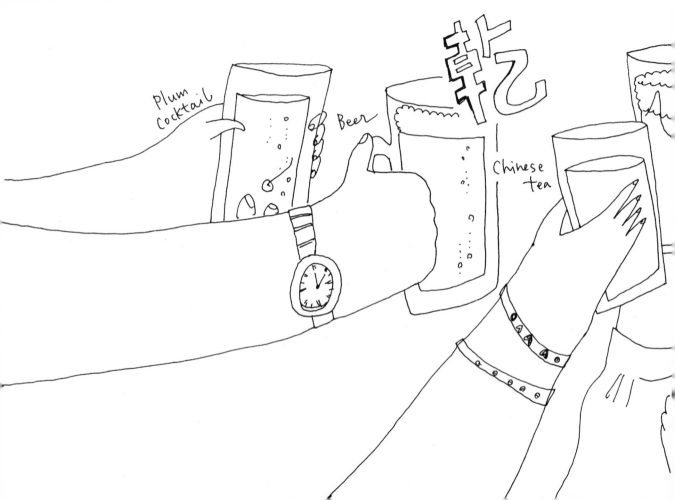

Plum cocktail

Beer

乾乙

Chinese tea

also I found the word
very dangerous and the illness
often happens again etc....
unfortunately my illness seems
very naughty Fuck off....

.... So what?

I had an argument with my mother
 again.

I think I was very bitchy ...

.... but so was my mother.

 it's been quiet for a while.
But, once again, the topic of the argument is "your health".
 But, in my mum's case, it's always pointless what she says
I do understand what she wants to say but I think it's a waste of time for
 both of us to argue about the same Th

I know that I should have consideration for mum.
but I wanted to carry on watching TV rather than
keep talking endlessly.
I know I'm a kid and a bitch. 9 th Sep 2002.

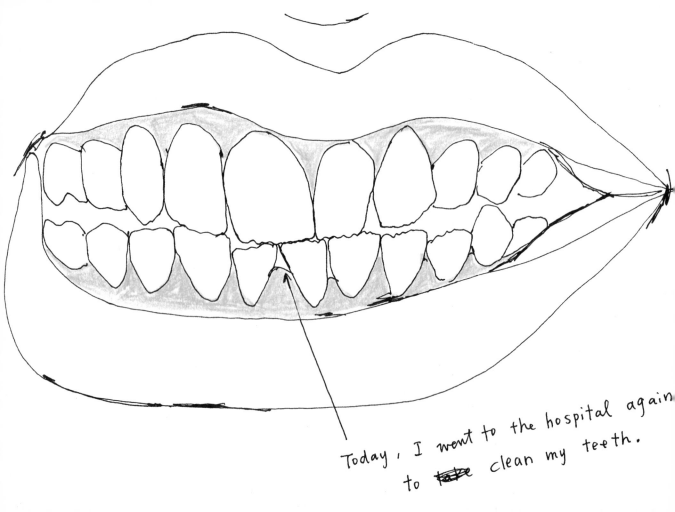

Today, I went to the hospital again to ~~take~~ clean my teeth.

Eh h H h h h h H H h

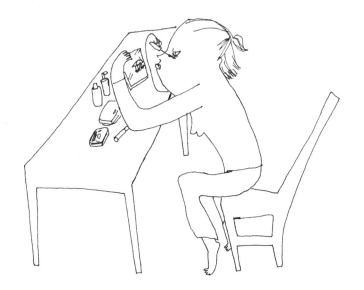

Yesterday, I had an appointment at the hospital.

24 / 10 / 0 2

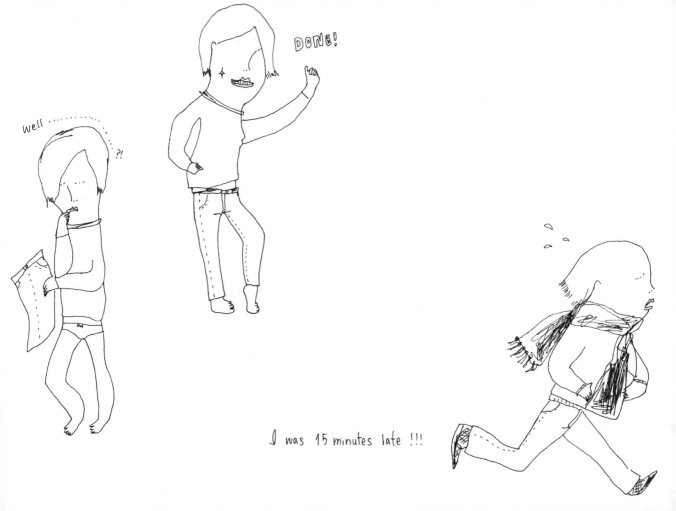

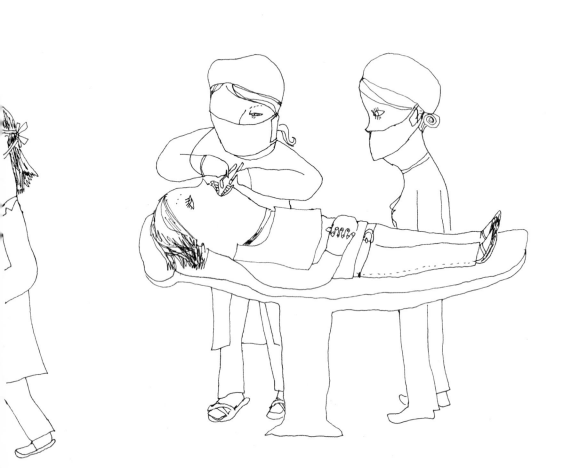

unfortunately, my lovely doctor wasn't there

actually, it was better

that the (lovely) doctor wasn't there.

Otherwise, I'd have had to show him the

embarrassing parts of myself ...

Well, to be honest,
the reason that I ☺ had the o
is because
I love kissing so
I didn't want 2 have a scar
on my tongue.

Fun: Office Lady

Ishii: working in a travel agency.

いつものメンバーで飲みに行った。で、つい つい しゃべりすぎてしまったの。
oh la~la ... stupid of me ... as usual , I talked too much.

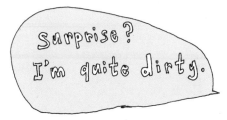

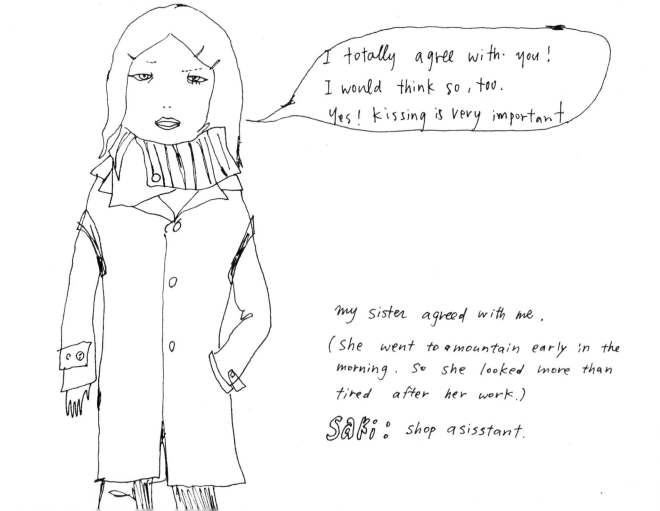

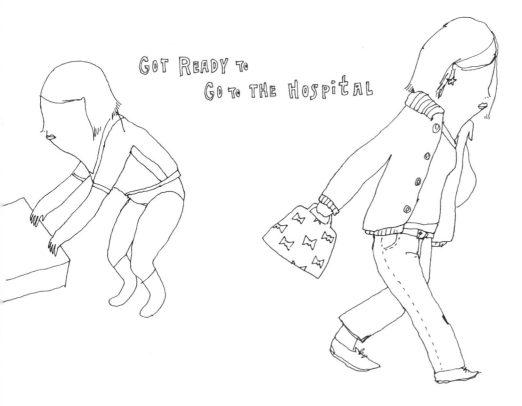

GOT READY TO GO TO THE HOSPITAL

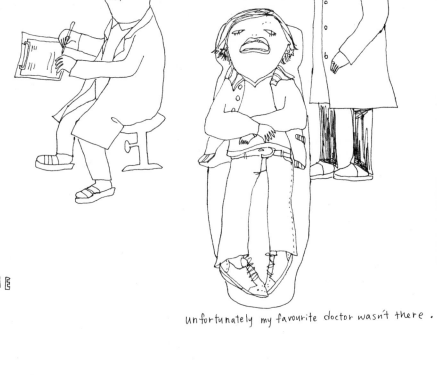

..... I WAS LATE, AGAINE

unfortunately my favourite doctor wasn't there .

TIME
14:30

always looking @ ceiling.

I hate it when the chair is going to lay down. It's uncomfortable.

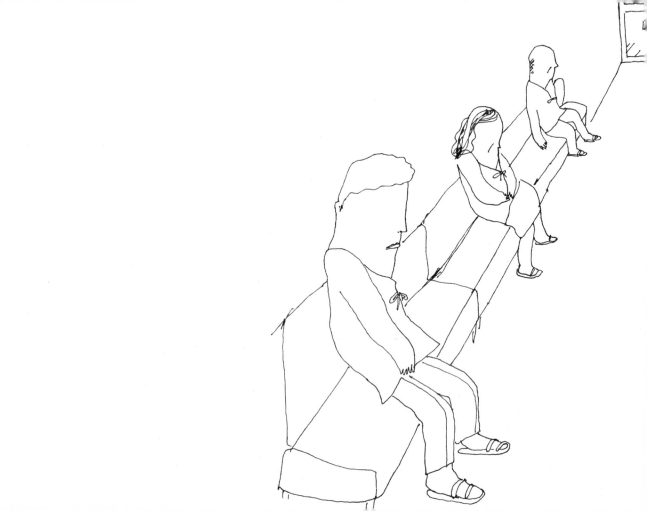

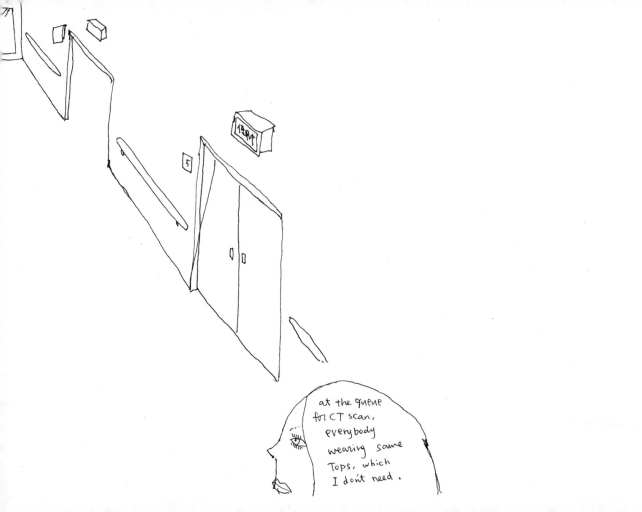

at the queue
for CT scan,
everybody
wearing same
Tops, which
I don't need.

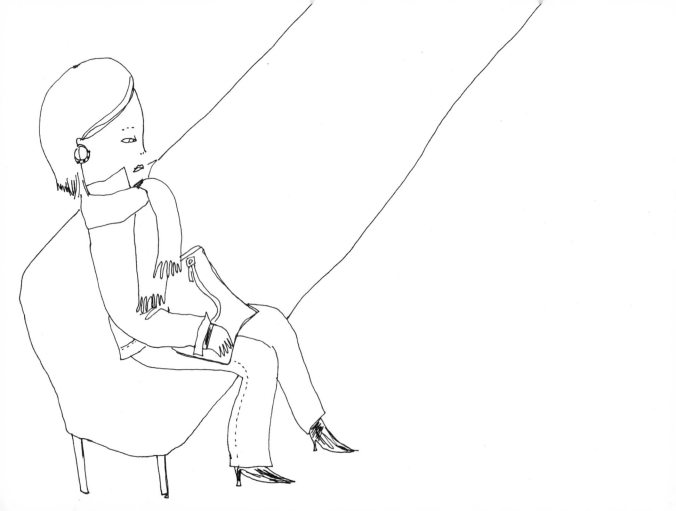

PREPaRAtioN →

Remove the metallic materials from the port where you shoot the CT. ①

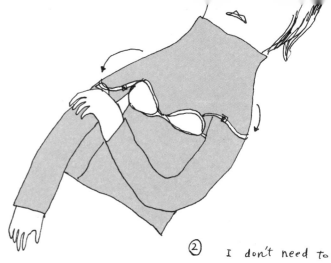

② I don't need to take my bla off. But, I had to put the strap down

REaDy! ⟶

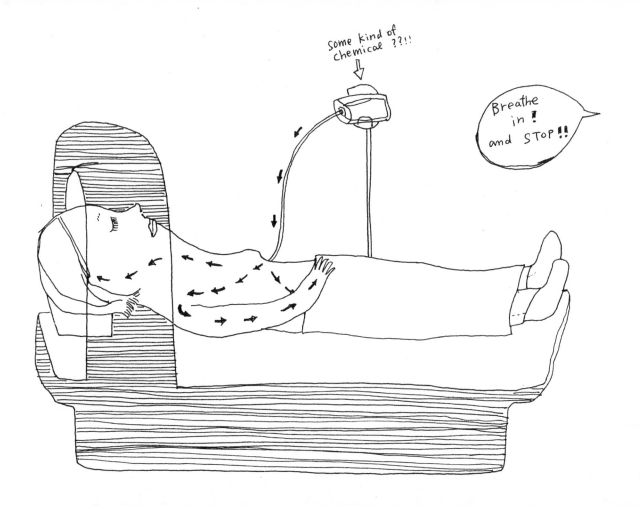

next wednesday,

Eehhh hhhhh hh hh

I'm late again . 27/11/02

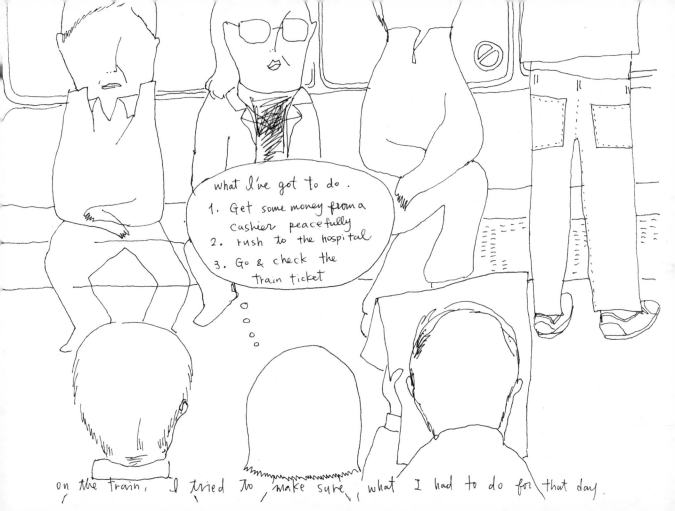

on the train, I tried to make sure what I had to do for that day.

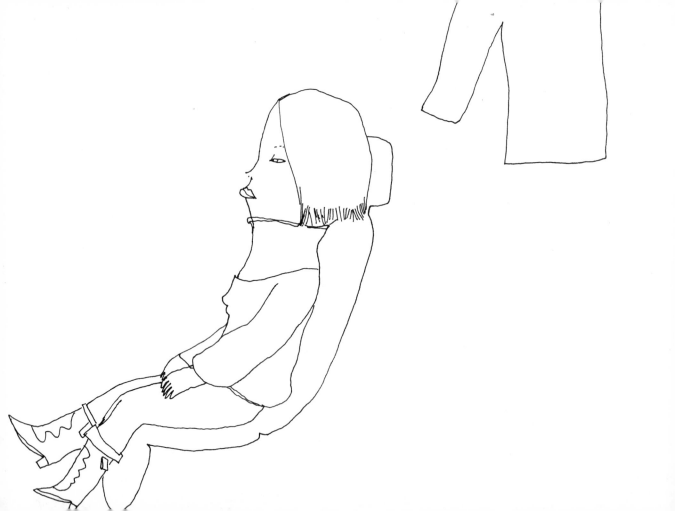

actually I finished the check quickly.

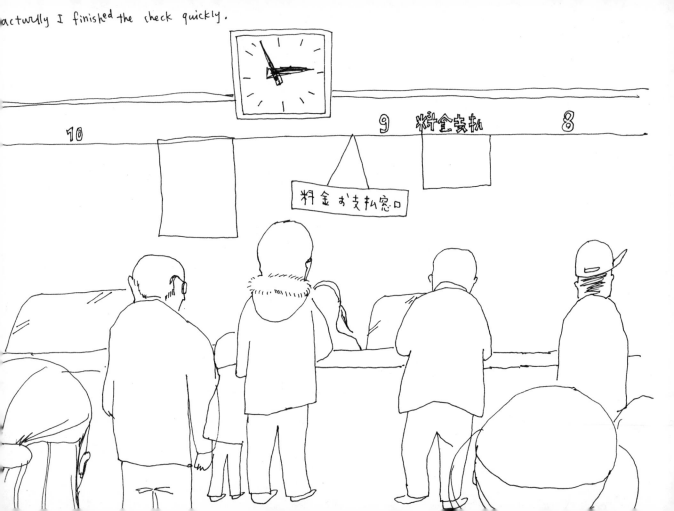

5th December, my sister insisted we have an

unhealthy LUNCH.

Fried chiken →
wrap.
FROM KFC

I knew that I've got see my dentist after this

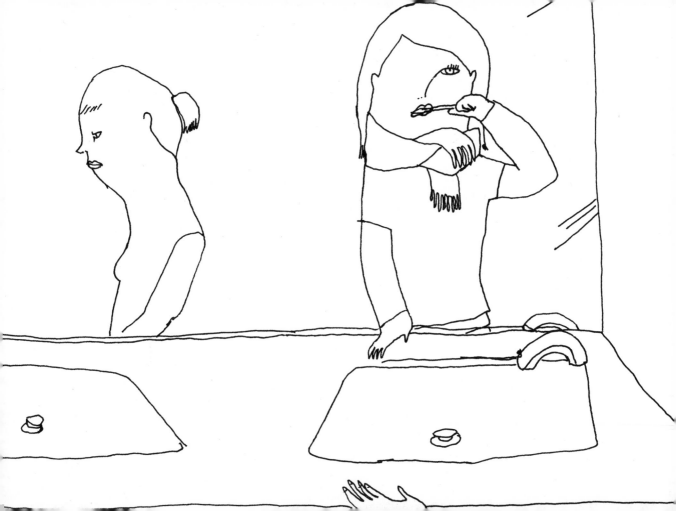

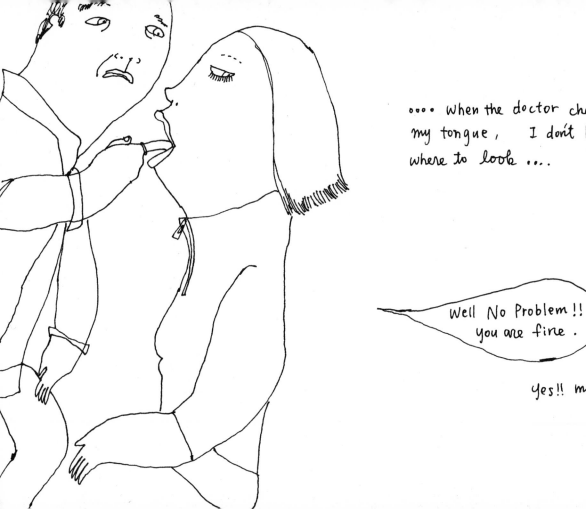

.... When the doctor checks my tongue, I don't know where to look ...

Well No Problem !! you are fine.

Yes!! my doctor said it!

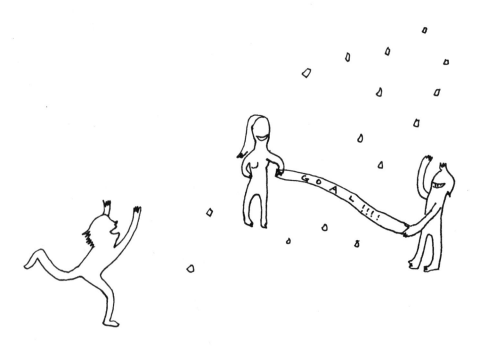

The GOAL is close!!

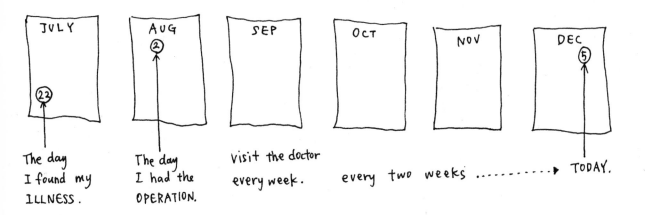

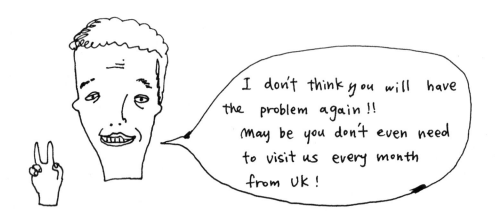

my main doctor said so!

... my mouth said so.

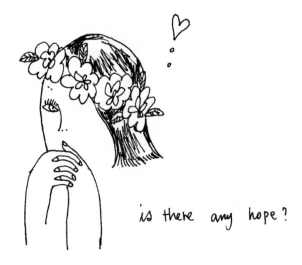

is there any hope?

…… 私って、本当に きんちょう感ないのねぇ?!。 っていうか、転がん 早すぎる かしら?

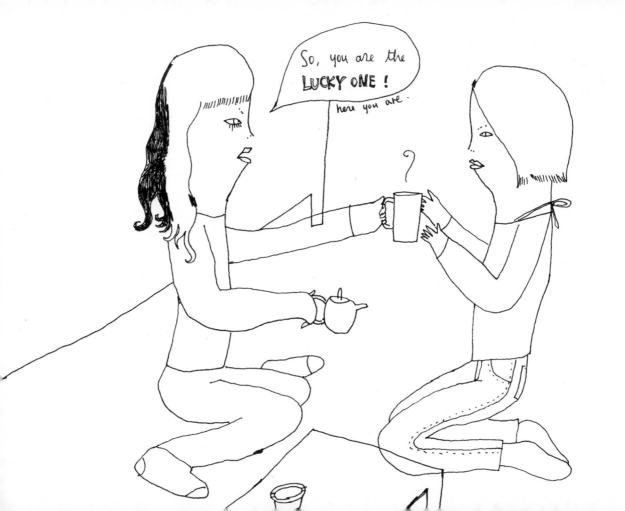

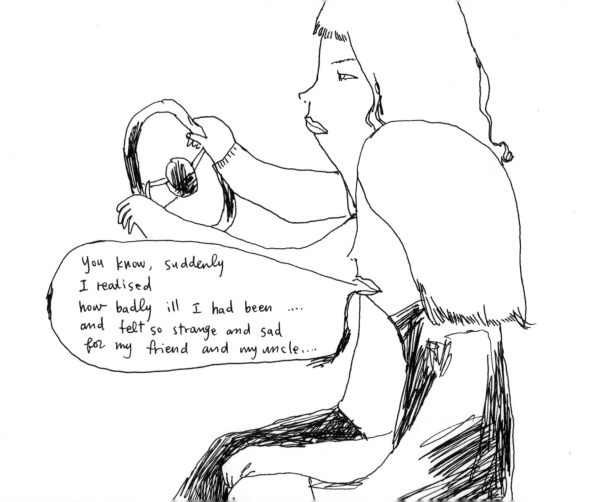

The ringing tone of our phone never changes but my mum is scared to pick up the phone these days. cos. she doesn't want to receive any bad news

R R

I'm not making you feel scared,
 but,
 the part where I cut my tongue has a
 strange feeling still .

But, it's not a big deal .

I like massage.
Really, I love it.
BUT NOW, I have to
be careful.
cos I'm not allowed
to have a massage
above the shoulders.

Dr. Nagano said "don't
touch your neck & head."

E ?!

Thus all the people around me
tell me

**Don't be stressed for
about ANYTHING!!!**

Well ... that's a bit difficult.

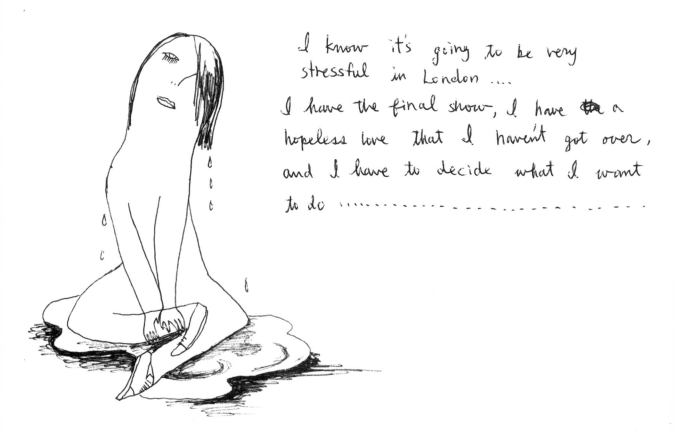

I know it's going to be very
stressful in London
I have the final show, I have the a
hopeless love that I haven't got over,
and I have to decide what I want
to do ...

But, those things (= stress ?!)
should not be a big deal ?!!!!!!!

Well, I see ...
I feel my body is lighter than before. *
just do whatever I want. ✦

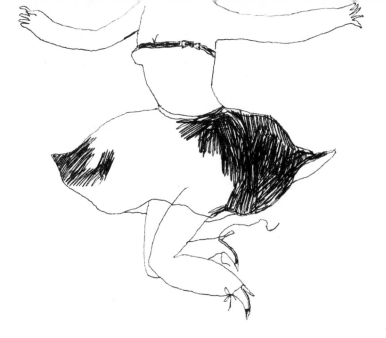

たのしむことだ。
ENJOY YOURSELF.

aknowledgement

Dear family , friends & doctors,
 Hurrah!! I made a book!!
oh, by the way, don't ask me
 how my Love ended. Guess!

 With a Million Loves
xxx Mio. 2007

Published by Jonathan Cape 2008

2 4 6 8 10 9 7 5 3 1

Copyright © Mio Matsumoto 2008

Mio Matsumoto has asserted her right under the Copyright, Designs
and Patents Act 1988 to be identified as the author of this work

First published in Great Britain in 2008 by
Jonathan Cape
Random House, 20 Vauxhall Bridge Road,
London SW1V 2SA

www.rbooks.co.uk

Addresses for companies within The Random House Group Limited
can be found at: www.randomhouse.co.uk/offices.htm

The Random House Group Limited Reg. No. 954009

ISBN 9780224084437

Printed and bound in China by C & C Offset Printing Co., Ltd